26 THINGS

THE SWISS NATIONAL MUSEUM
SCHEIDEGGER & SPIESS

26 THINGS

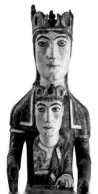
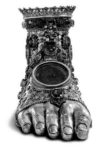
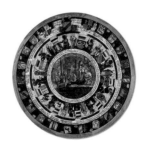

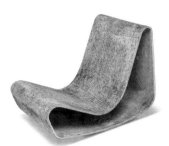

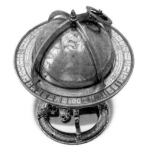

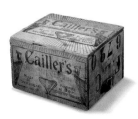

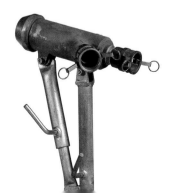

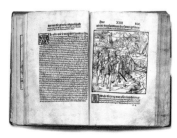

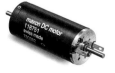

Things from 26 cantons

Most modern-day objects are a familiar sight. But when it comes to objects from the past, we frequently find that we have to decode them. This can be a tricky and complex task, but if we persevere, we may earn ourselves an entrance ticket to the past. Certainly the method employed by Jacob Burckhardt, a scholar and cultural historian from Basel, was to immerse himself in a contemplative study of the past and explore history in an unsystematic and open-ended manner.

Artefacts from the past left to us by people on the north and south sides of the Alps in the territory of modern Switzerland attest to their extraordinary craftsmanship and artistic skills. Approximately 850,000 such artefacts are kept in the Swiss National Museum today. The history of a piece of pottery, a clock, a liturgical object, a weapon, or a stained-glass work represents both a source and a tool for museums, researchers, and aficionados of cultural history to work with. The following supporters and friends, united in the Society Landesmuseum Zürich and the Association des Amis du Château de Prangins, have made the publication of this catalogue possible:

Catherine Ming, President Association des Amis du Château de Prangins
Walter Anderau, President Society Landesmuseum Zürich
Andreas Spillmann, Director The Swiss National Museum

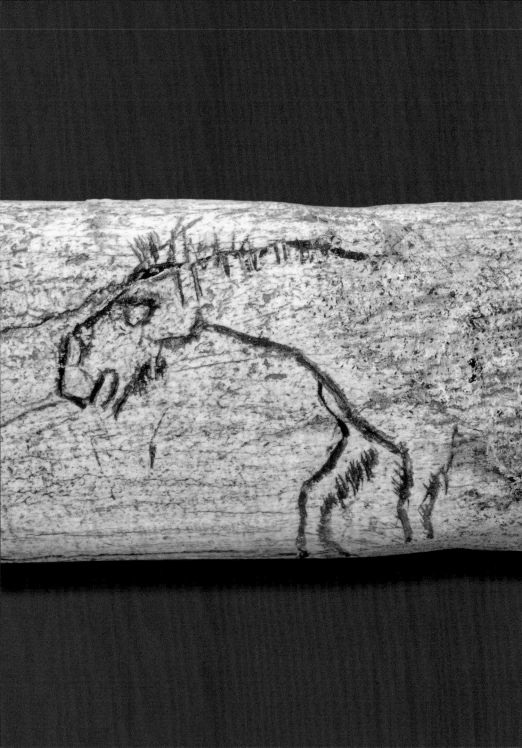

Canton of Schaffhausen
Perforated baton | 11th century BC |
reindeer antler |
found in the late 19th century in Schweizersbild |

Magic in Palaeolithic times

When the last Ice Age was drawing to a close 15,000 years ago, human beings found a perfect shelter under an overhanging rock in the canton of Schaffhausen. Here they ate and drank and worked with flint tools and sewing needles.

The campsite was discovered in the 19th century in Herblingen, a quarter in the town of Schaffhausen. One of the artefacts found there was a perforated baton made of reindeer antler with two incised wild horses.

This is one of the oldest figural representations to be found in Switzerland. The purpose of this artefact in Palaeolithic times is unknown. Archaeologists believe that it may have been a magical implement used during hunting. Drawing is thought to have been a magical act, and hunting magic was used to gain power over the animals and ensure good fortune on the hunt.

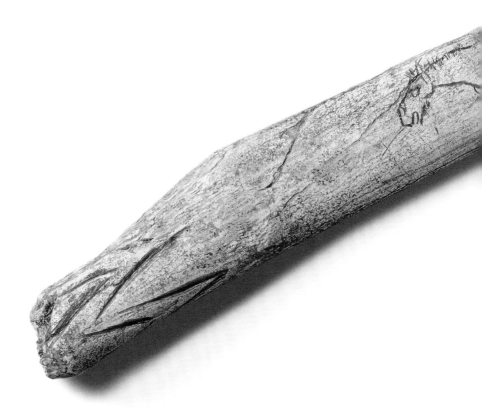

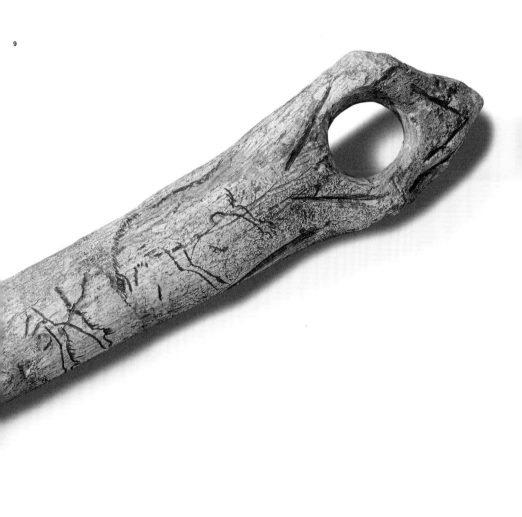

Canton of Zurich
Golden bowl | 12th – 10th century BC |
gold | chased |
found in 1906 in Zurich-Altstetten |

The gold-digger of Altstetten

In the canton of Zurich, one would not expect to find gold anywhere except on the "Goldcoast" and on Paradeplatz. The labourer who was working on the railway line in Altstetten in 1906 must have thought he was dreaming when he spied a glint of gold among the dirt. What he had unearthed was a richly decorated golden bowl that turned out to be a highly significant artefact from the Bronze Age: a precious vessel that had lain in the earth's protective embrace for around 3000 years.

The bowl is adorned with suns, full moons, and sickle moons. Even the lustre of the precious metal symbolises the heavenly bodies. The people of the Bronze Age used the stars to find their way and could read the change of the seasons in their movements. They were aware of the influence of the sun and moon on crops and fruits and adopted them as symbols in the rituals they performed.

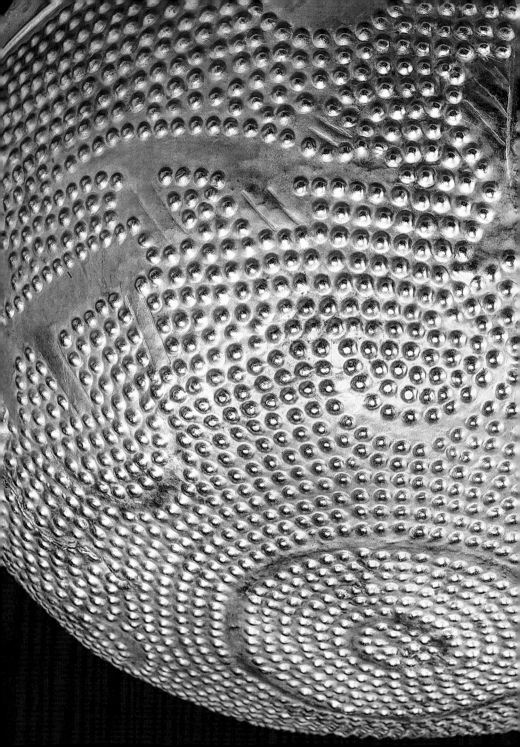

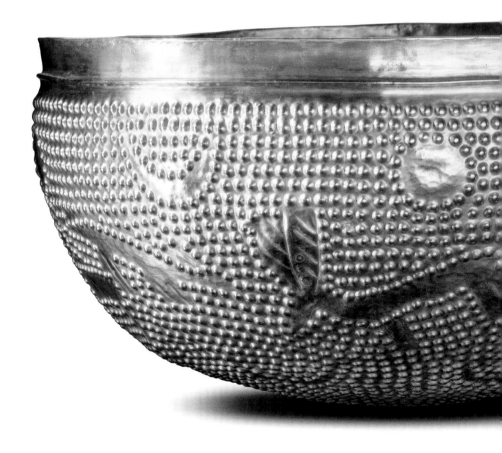

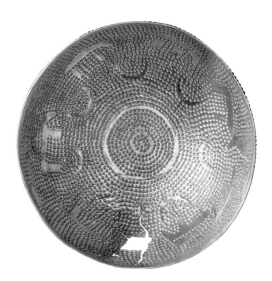

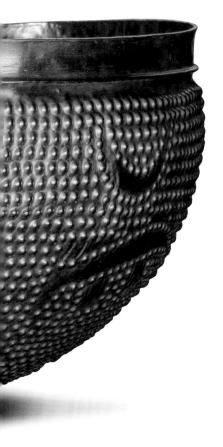

Canton of Ticino
Mercenary's helmet | 1st century BC |
bronze | chased |
found in 1900 in Giubiasco |

It's all in the shape

It began when a farmer in the canton of Ticino found an old gravestone in 1900. Soon it became clear that what lay buried there was not just a collection of old bones. In fact, there were over 500 such graves, all dating from the Iron Age. About one-fifth of the burials were warriors who had been interred with their lances, shields, swords, and helmets. The Roman Empire had taken to hiring mercenaries to aid its expansion to the north towards the end of the Iron Age. Mercenaries used their own weapons and armour, and the helmet found in the grave has been identified as belonging to a mercenary who came from the Central Alps.

The mercenaries would return to their homes after completing their period of service. When they died, they were given a warrior's funeral as befitted their status, like this man from Giubiasco, whose origins are revealed by the shape of his helmet. It's all in the shape. Even in archaeology.

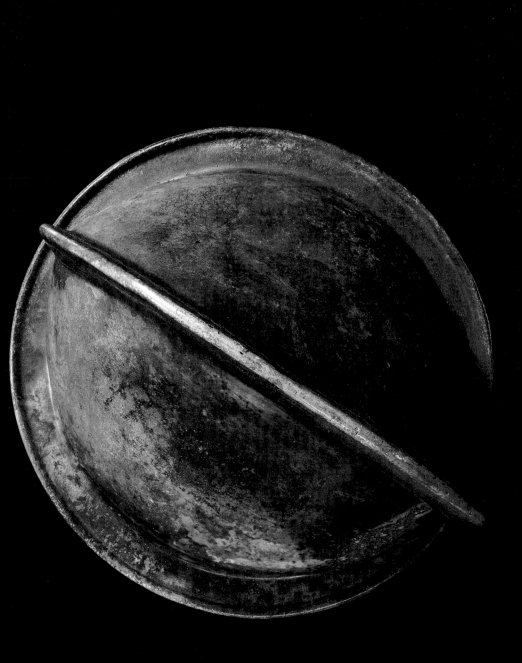

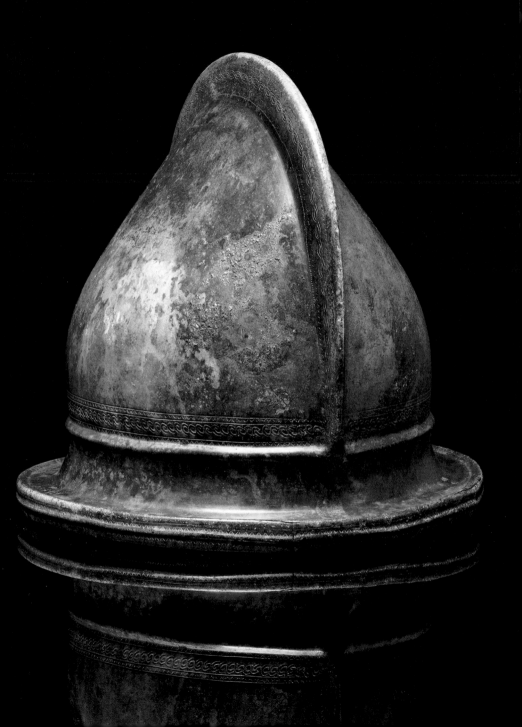

Canton of Solothurn
Disc fibula | end of 6th century AD |
gold | bronze | semi-precious stone |
found c. 1900 in Oberbuchsiten |

How the "Röstigraben" came to be

This brooch, called a fibula, belonged to a woman living in what is today the canton of Solothurn around the year AD 600. It is made of gold and set with semi-precious stones. The fibula was used to fasten a cloak over the wearer's chest – a fashion the Germanic tribes had brought to Switzerland.

The Germanic migration not only brought changes in fashion, customs, and diet to Switzerland, but also multilingualism. While the Alemannians imposed their own language on the north of the country, the Germanic tribes of the Langobards and Burgundians in the south and southwest adopted the Latin language of the local population. So it is thanks to the Germans that Switzerland is divided into German-speaking and Romance-speaking residents today.

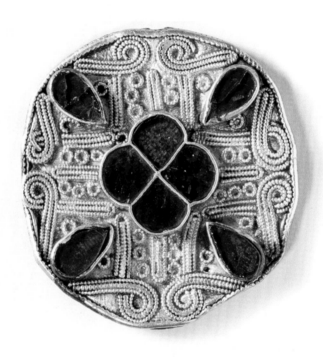

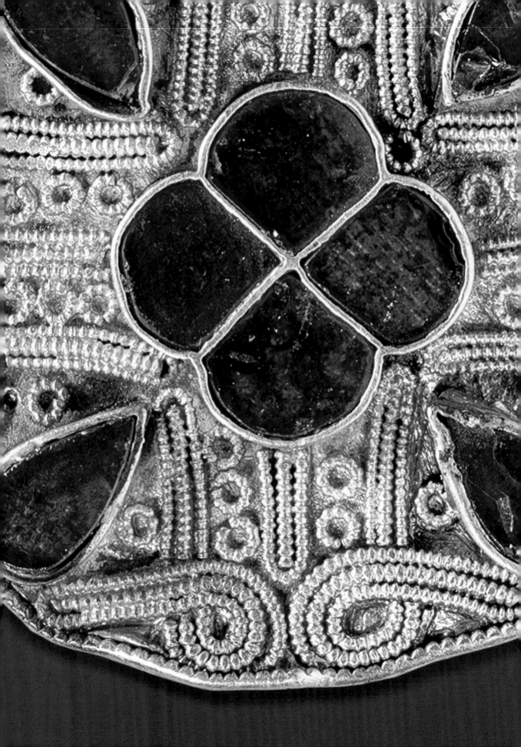

Canton of Valais
Madonna and Child | 1170 |
limewood |
found in 1924 in Raron |

An unusual Sleeping Beauty

It was not roses that guarded the sleep of the enthroned Madonna with the Child, but human bones. And her sleep lasted not for a hundred years, but for several centuries. The sculpture was piously buried in the charnel house of the church of Raron according to a custom prevalent in Europe at the time, and gradually vanished beneath the skulls and bones of the dead.

The reason for burying the wooden figure was provided by the rebuilding of the parish church between 1510 and 1515. The Romanesque Madonna had fallen out of fashion and was no longer needed.

The person who finally kissed her awake again was not Prince Charming, but a tradesman from the canton of Valais. During restoration work on the charnel house of Raron in 1924, he was told to clear out the bones – and so he stumbled upon several sculptures, including the most significant example of Romanesque art in Switzerland.

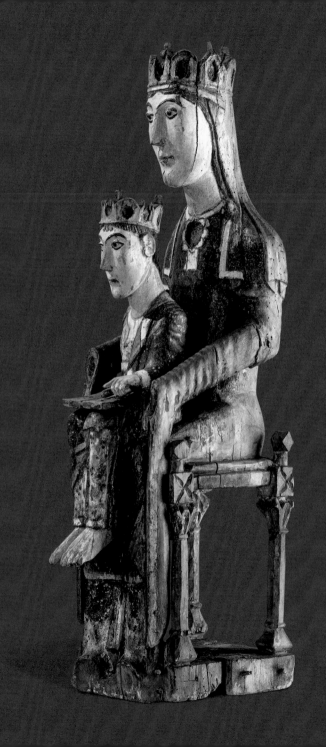

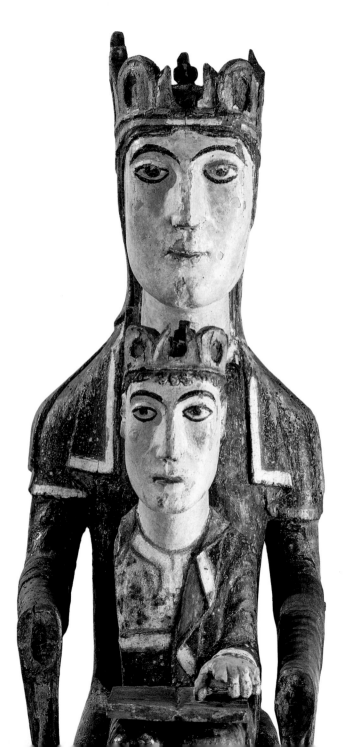

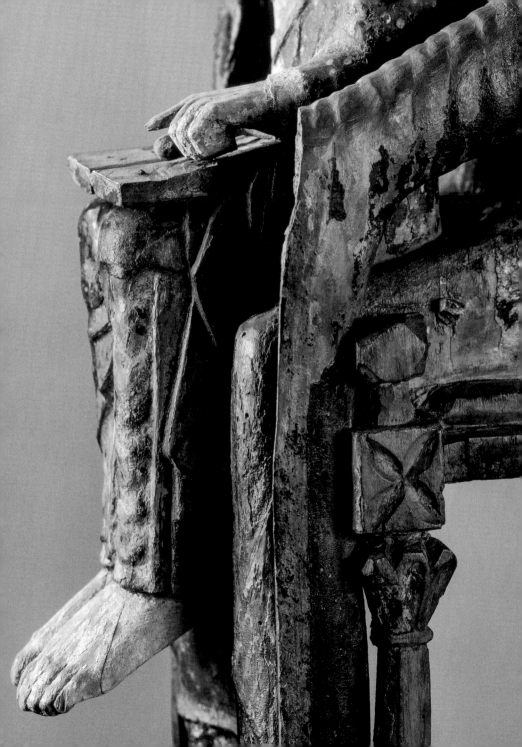

Canton of Uri
Battle shield | c. 1200 |
alder wood | animal skin | plaster and chalk primer | painted |
from the women's convent of Seedorf |

Oh for the good old days! Or not?

Some people insist that everything was better in the good old days. And it is true that this battle shield – the oldest of its kind that survives – was once resplendent with bright colours. Analysis has shown that what we see as a greyish green today was a vibrant blue 800 years ago, and that the dull-coloured lion used to be covered with shiny silver leaf.

The shield belonged to the noble house of Brienz, which had feudal rights on the route to the Gotthard in what is today the canton of Uri. When its owner, the knight Arnold von Brienz, died in 1225, the shield was hung above his last resting-place as a memorial to the deceased, and thus the valuable artefact was preserved for posterity.

The notches, holes, and gashes in the shield bear witness to the brutal reality of medieval battlefields.

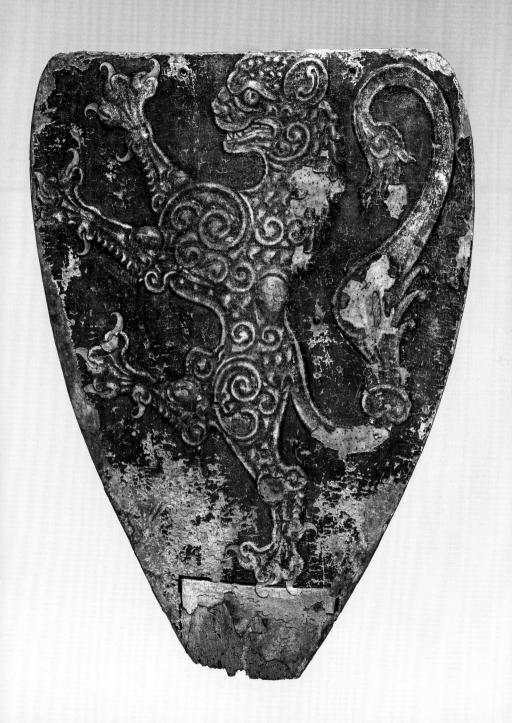

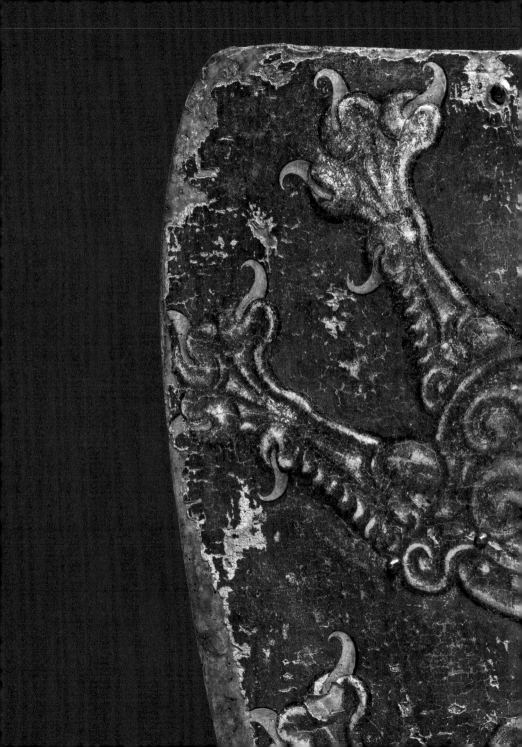

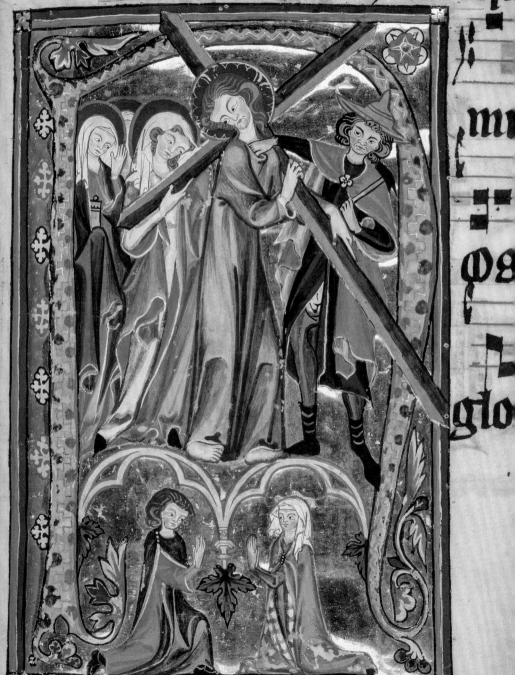

Canton of Thurgau
Gradual | 1312 |
parchment | illuminated |
from the St. Katharinental abbey in Diessenhofen |

A heavyweight of cultural history

Some things are made to last forever. One of them is the Gradual from the St. Katharinental Abbey in what is today the canton of Thurgau. The late Gothic hymnal was created in 1312 and was used in the abbey for approximately 500 years. Because it was kept locked away between uses, the Gradual is in excellent condition and the colours of the precious miniatures adorning the pages have lost none of their brilliance. The book was opened only while the nuns sang from it during Mass. They would stand on the choir steps so that they could all read from the book at the same time. The name "Gradual" derives from the Latin word gradus meaning "step". The book is almost half a metre tall to enable all the nuns to read the liturgical chants. This Gradual is one of the most valuable manuscripts in Switzerland. Weighing thirteen kilograms, it is also a true heavyweight of cultural history.

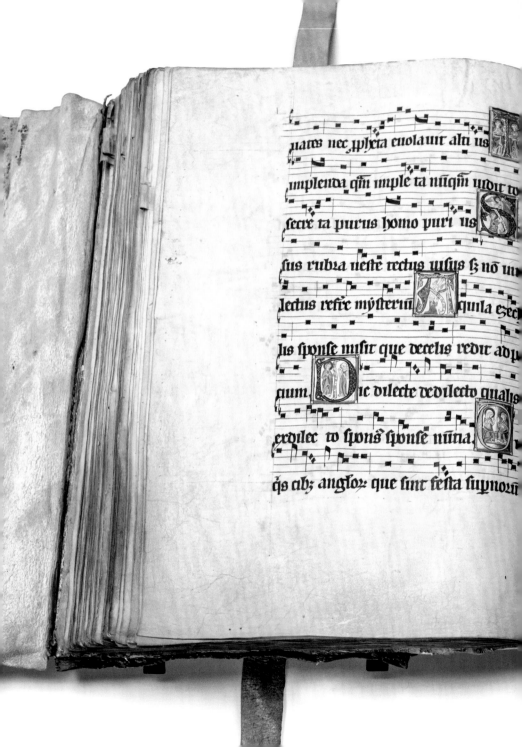

uaros nec ppheta euolauit altius

implenda qm imple ta nnqm uidit to

secre ta purus homo puri us

sus rubra ueste rectus uisus sz no in

lectus resic mysteriu aquila ezech

lis sponse misit que decelis redit adp

quam ic dilecte dedilecto qualis

pdilec to sponsz sponse nunia.

qs ab; anglox que sint festa suprnozu

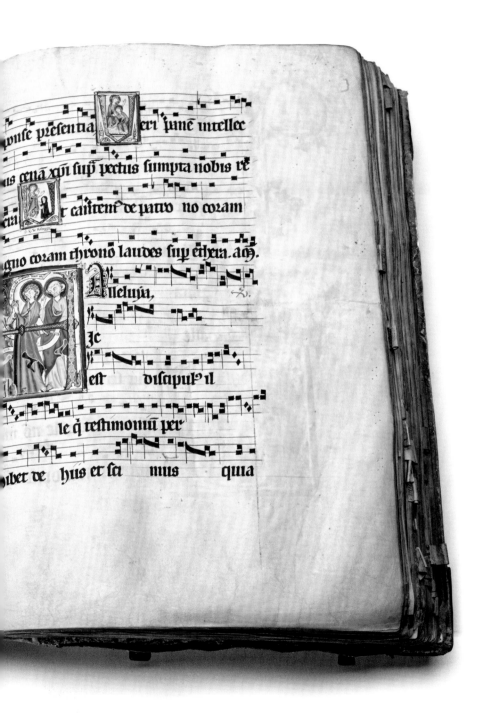

...onse presentia ...eri pane intellec

...us cena xp̃i sup̃ pectus sumpta nobis re

...cia ...t cantrem de patre no coram

...gno coram throno laudes sup̃ ethera. ah.

Alleluia.

...c

...est discipul' il

...le q̃ testimoniu per

...ibet de his et sci mus quia

Canton of Basel-Landschaft
Foot reliquary | 1450 |
silver | copper | gold-plated | mother of pearl |
enamel | pearls | gemstones | glass |
from the Basel Minster treasury |

A window on a supernatural helper

When the canton of Basel was divided in two in 1833, the famous treasure of the Basel Minster was shared between the two new cantons, with Basel-Landschaft receiving 64 percent. The ecclesiastical treasures were sold to raise urgently needed funds, including the silver reliquary dating from 1450, which fetched 562 francs for the canton's coffers. It is shaped like a foot to reflect its contents – what were believed to be the foot bones of a little boy murdered in Bethlehem on the orders of King Herod.

While this might strike modern observers as creepy, believers regarded such relics as objects of religious veneration. A window of polished rock crystal allowed the relics to be viewed by the public on feast days, and churchgoers hoped that a glimpse of them would allow them to obtain divine aid.

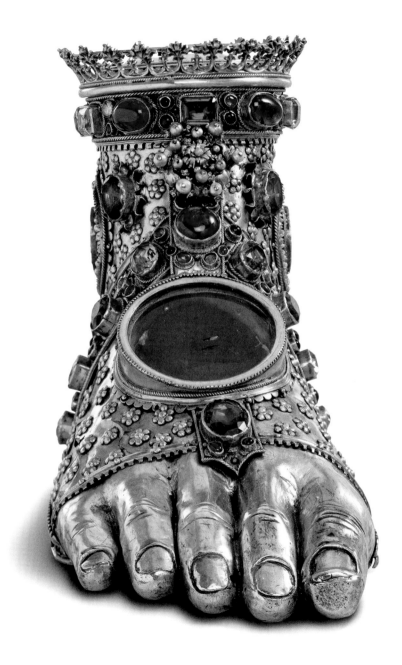

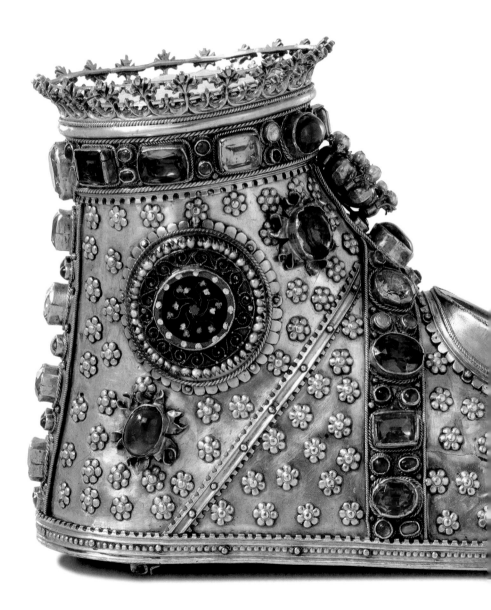

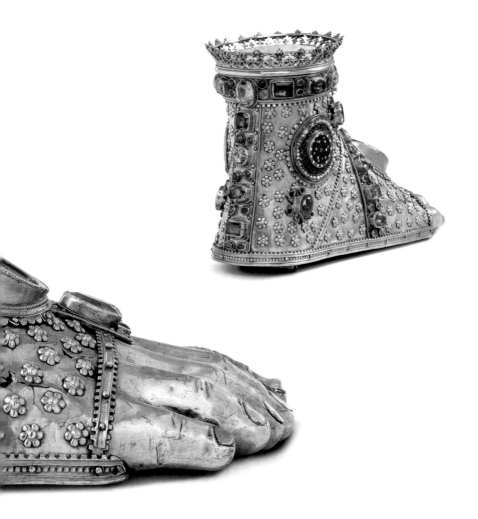

Canton of Schwyz
"Hortus Conclusus" church tapestry | 1480 |
wool | silk | gold and silver thread | arrased |
from the Kreuzkapelle in Lachen |

A medieval riddle

In our time, people who want to improve their logic skills might do a Sudoku while commuting on the urban railway. In medieval times, people would spend their time decoding the immense iconographic programme of the Catholic Church, which included not only Biblical figures and saints, but also legendary creatures with no religious connotations. The creator of the "Enclosed Garden" that can be seen on a precious tapestry from the chapel of Ried in what is today the canton of Schwyz drew on the early Christian natural history treatise known as the "Physiologus", which states that a unicorn can only be captured by a virgin. From a Christian viewpoint, the virgin is Mary and her touching the unicorn's horn is an allusion to the immaculate conception.

Interpreting this scene correctly was tricky, but within the capabilities of medieval churchgoers. In contrast, they were less adept at understanding written letters and numbers.

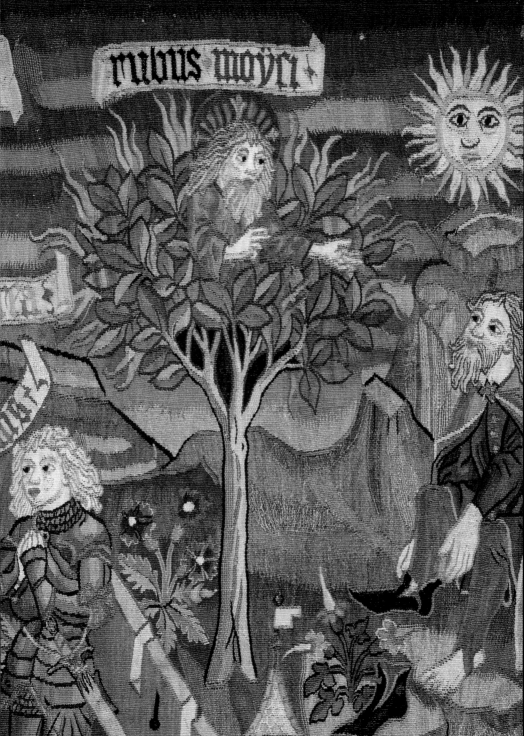

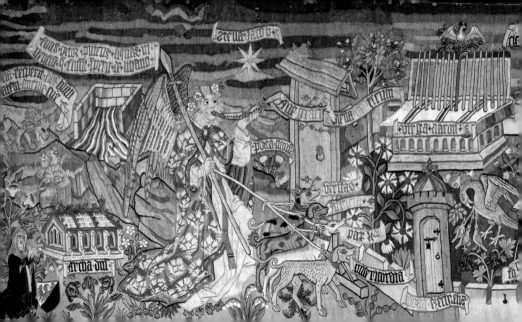

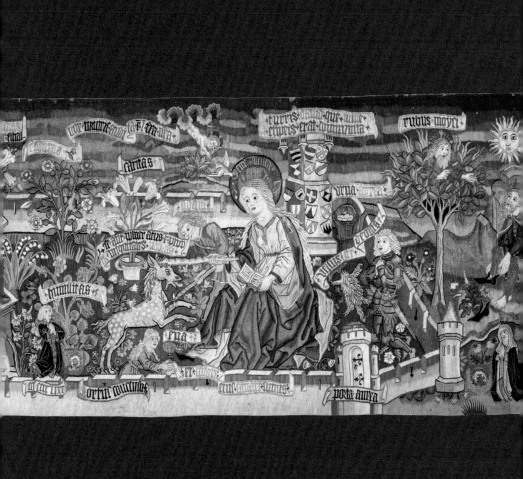

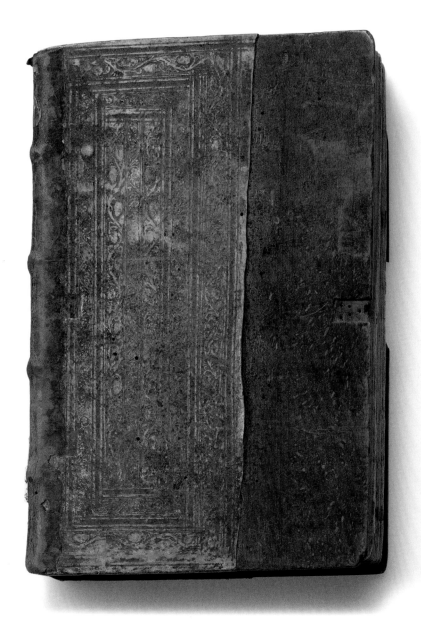

Canton of Lucerne
Chronicle of the Swiss Confederation | 1507 |
paper | woodcuts |
written by Petermann Etterlin |

The Swiss foundation legend

Walter stands under a tree, his head inclined to one side. His father, Wilhelm Tell, takes aim at the apple with his crossbow. If he hits his son instead of the fruit, the second arrow, stuck into his doublet, is destined for the bailiff. This iconic motif, which has become so deeply ingrained in Switzerland's collective consciousness, is found in the first comprehensive chronicle of Swiss history. The work tells of the foreign bailiffs who appropriated solidly built stone houses and sought to seduce faithful wives. In response, the people of Schwyz, Uri, and Unterwalden banded together to resist their foreign overlords.

The chronicle was written between 1505 and 1507 by the Lucerne historian Petermann Etterlin. Thanks to the advent of printing, Etterlin's version of the Swiss foundation legend circulated widely and continued to influence great artists, including Friedrich Schiller and Gioachino Rossini, for centuries to come.

Kronica
von der
loblichen Eydtgenoschafft
jr harkomen vnd sust seltzam
stritten vnd geschichten zesamē gevaßet
durch
Peterman Etterlyn
gerichtschreiber zu Luzern.

getruckt von Michael Furtter in Basel.

1401.

wo von die gemein eydgnoschafft
entspiungen ist Vnd was mittwillens der Landt-
vogt zů Ury vnd Swyg getriben hart.

Es alles wie ir vorgehört handt zů Vn-
derwalden vergangen was / fügte sich das in den selben
zyten / Eyner vo Swyg genant der stösser der sass zů
stemmen die dishalb der Burg / der hart gar ein hübsch hus
gebuwen do erit essen zyt. Der Gryßler der hatt den dann ouch zů
des Richs handen zů Ury / vnd zů Swyg vogt was das für
vnd erfische dem stösser fragt in wes die hübsch behusig wer. Der stöf-
fer sucht in / dann er wust wol / das er ein tyran vnd böser mensch was /
antwurt im schlechtlich vnd sprach / gnediger herr es ist ůwer gnaden
vnd mins lehen / vnd sedossit von rouchen wegen nit sprecht sy ist min / der
herr schweyg stil vñ reit do hin / Tu was der stösser gar ein wenig wer
nünftiger man hart ouch des glichen eyn from wyb frowen / was dar in
wolabeden vnd zügen / Der nans sich nun der selben der vnnd satz sie zů
hertzen bekümbert sich vnd sorcht alwegen der herr näme in hyb vnd güt /

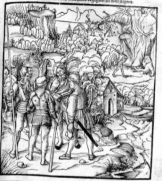

Das XIIII blat.
wie die dryg landtman so zesamen geschwo-
ren ander from lüt den ouch allerhand begegnet zů men zügen.

Vnd als die dryg man also einanderen ge-
schwoi harten / do was ir anschlag das iegklicher vnder in
süchen vnd heimlichen fragen solten wo sy mer lütten möch-
ten finde vñ zů men dingen / Also funden sy den / der den her-

C iij

Canton of Zug
Stained glass window with cantonal coat of arms | 1507 |
glass | painted | black stain |
artist unknown |

A display window in the 16th century

Politicians everywhere depend on having a strong public presence, and Swiss politicians of the past were no exception. Starting in the 16th century, houses and churches increasingly began to feature stained glass windows showing coats of arms. The citizens rebuilt their houses in stone – an expensive undertaking requiring financial support from wealthy burghers, neighbours, or guilds. As a token of thanks, the donors' coats of arms were displayed in the windows to bear witness to their generosity.

Both the "crowdfunding" for new houses and the craft of making cabinet panels very quickly became established. Being able to display the coat of arms not of a random fellow-resident, but of the government, in one's window was something special. The 13 cantons were soon inundated with requests and later confined their sponsorship to public buildings. This happened too in the canton of Zug, which donated this pane to the town hall of Lachen (SZ).

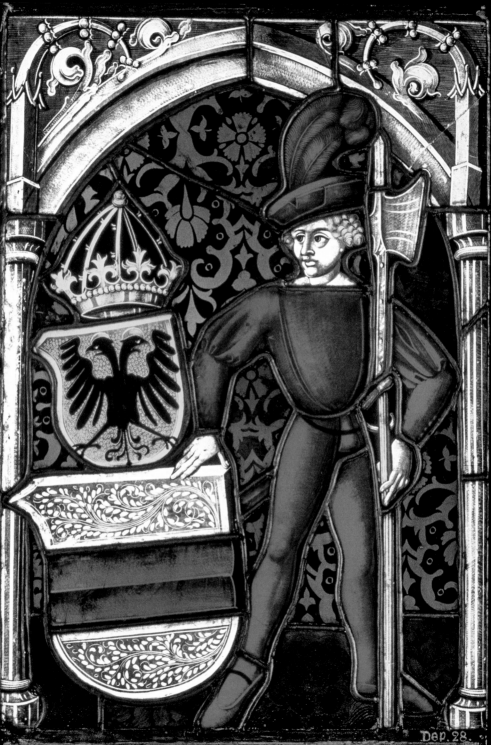

Canton of St. Gallen
Celestial globe | 1594 |
clockwork | brass | silver | gold-plated | cast |
repoussé work | chased and engraved |
made by Jost Bürgi |

An ingenious timekeeper

As everyone knows, 29 February is a leap day and appears on the calendar only once every four years. The day was introduced in 1582 by Pope Gregory XIII. The new Gregorian calendar finally did justice to the fact that a year has 365.2425 days.

Only four years later, Jost Bürgi, a brilliant astronomer, mathematician, clockmaker, and maker of astronomical instruments, built a celestial globe incorporating the new calendar for the German Kaiser. He developed the first-ever mechanical system to display 29 February in leap years. Bürgi was born in what is today the canton of St. Gallen and worked with the famous astronomer Johannes Kepler at the imperial court in Prague.

In addition to the celestial globe, he also invented many other things. He was the first person to draw up a logarithmic table. Additionally, he built a clock with three hands, thereby creating the second as a unit of time.

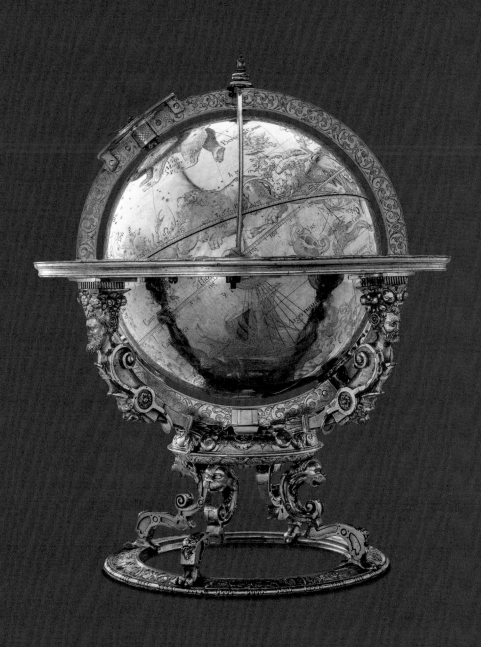

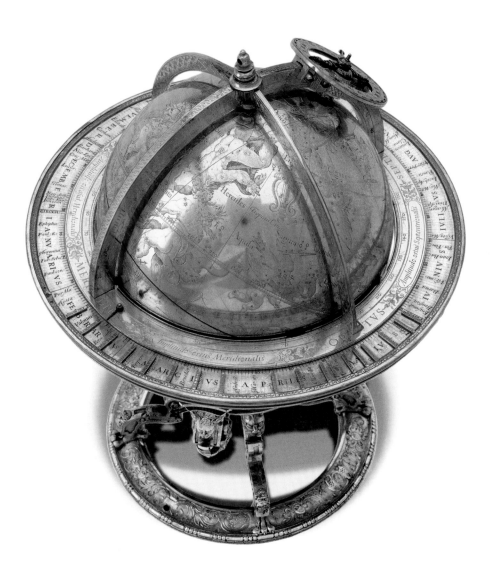

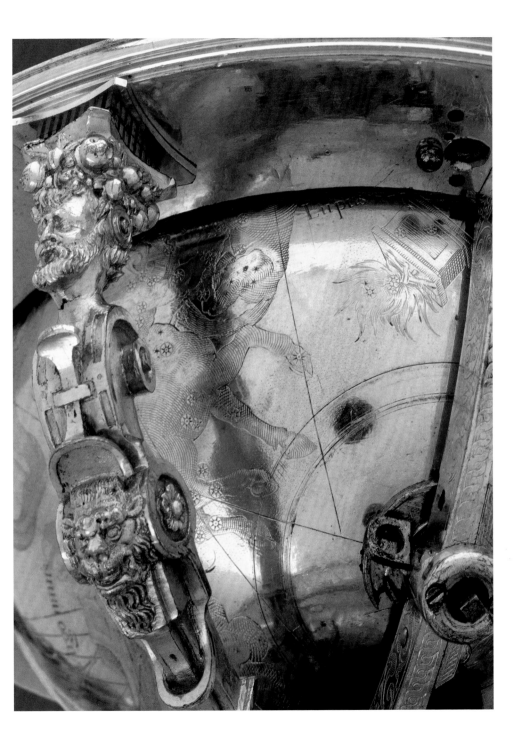

Canton of Nidwalden
Renaissance chamber | 1602 |
wall panelling | coffered ceiling | clay tiles | relief tiles |
reception chamber from the Rosenburg in Stans |

If you've got it, flaunt it!

Rich people love to show off their wealth – and this is equally true of the wealthy people of the past. In the 16th century, Johannes Waser rose to the top of the military and political hierarchy in Switzerland. Through his wife, Margareta Zelger, a substantial building in Stans known as the Rosenburg came into his possession. Having become a person of consequence, Waser converted the Rosenburg into a representative palais. He paid special attention to the accoutrements of his renaissance-style reception chamber, in which only the costliest materials were used for the wall panelling, the coffered ceiling, the sideboard, the tiled stove, and the floor tiling. The chamber sent a clear message to his visitors: Look at me, I'm a person of consequence!

In 1897, the architect Gustav Gull installed the chamber from the canton of Nidwalden in the newly created National Museum Zurich. There, Waser's reception chamber became a crowd-puller.

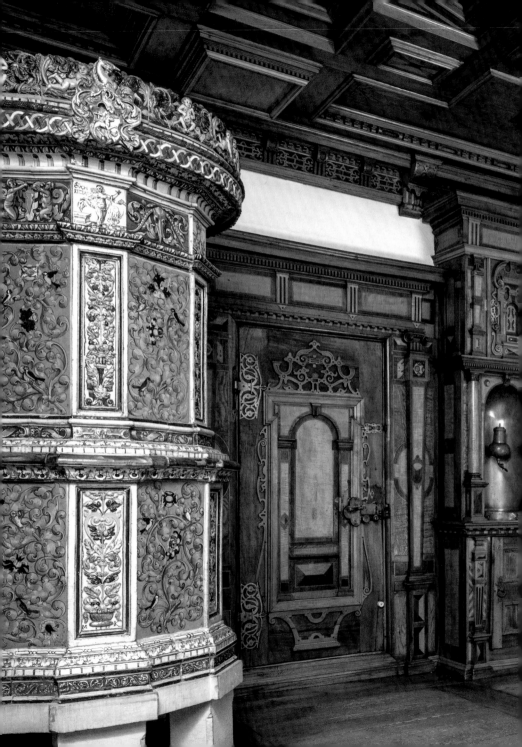

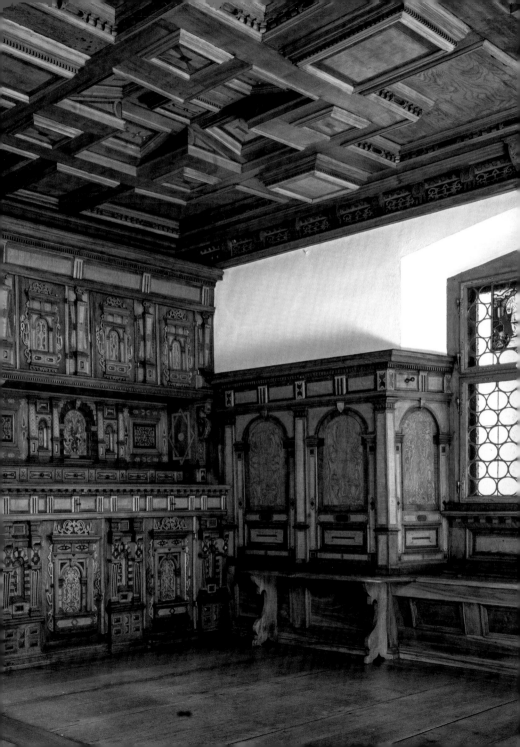

Canton of Appenzell Innerrhoden
"Ratsrose" painting | 1688 |
canvas | oil | wood |
attributed to Johann Martin Geiger | from the Appenzell town hall |

Teamwork

In Switzerland, government is a team effort, not a one-man-show. Political power is distributed among numerous authorities and many different people, and as a result, Swiss governments do not have just one head of state, but several – seven as a rule. On all three administrative levels – federal, cantonal, and municipal – the executive authority operates on the principle of collegiality. In Switzerland this form of government goes back to the early days of the city and peasants' republics. The circular painting known as the "Ratsrose", which hung in the cantonal parliament of Appenzell until the late 19th century, dates from the ancien régime. The outer ring shows the names and coats of arms of the members of the Privy Council, which was responsible for fiscal, foreign, and church policy. The inner ring shows the political system of Appenzell Inner-Rhodes, where the political and military entities were known as "Rhodes".

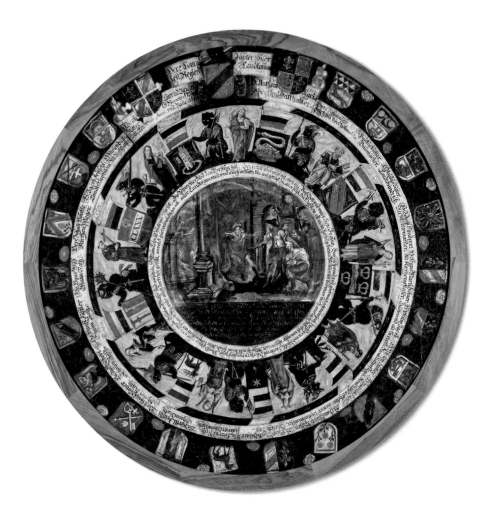

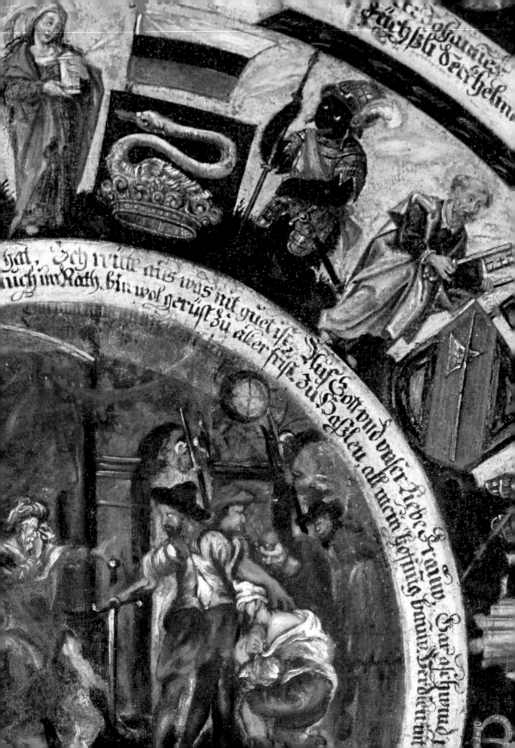

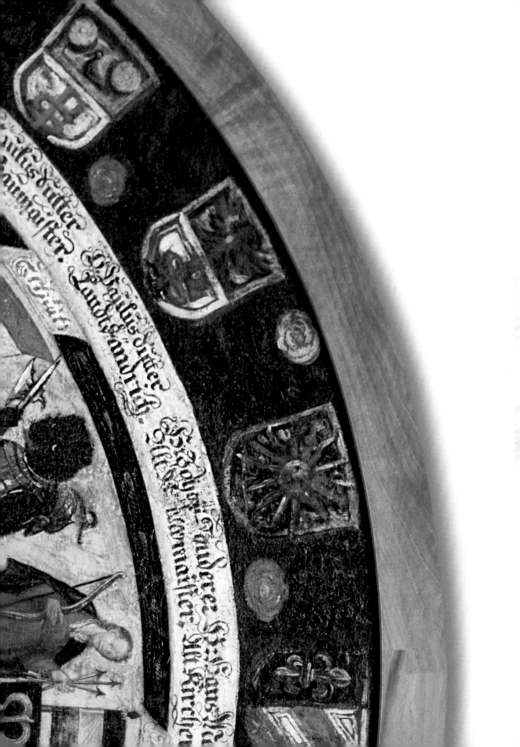

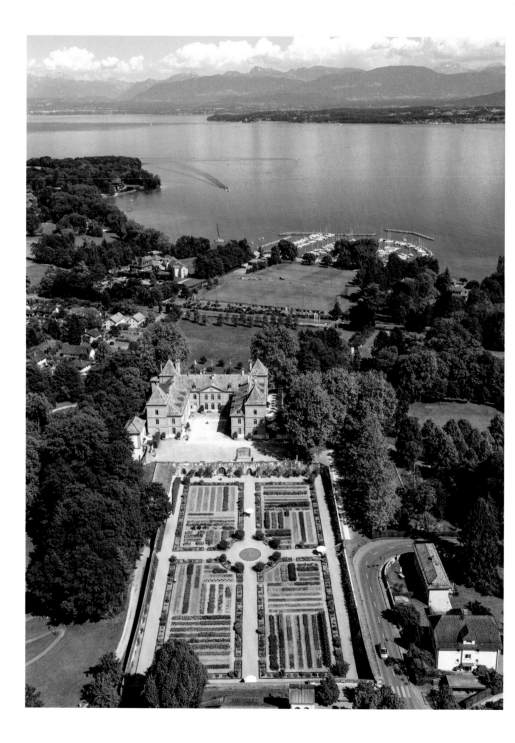

Canton of Waadt
Jardin potager | 1729 |
historical vegetable garden |
laid out by Baron Louis Guiguer in Prangins |

Gardening stories

Today's guerrilla gardeners plant pumpkins, maize, and beans and let tall sunflowers grow in public places. In the new trend of urban gardening, greenery is lovingly planted in every available space, while window boxes and plant pots allow miniature gardens to grow on balconies. In the past, space for gardens was much easier to find and there was nothing rebellious about tending a garden. Magnificent formal gardens were demonstrations of status and power. One such garden is that of the Château de Prangins on Lake Geneva in the canton of Waadt. Baron Louis Guiguer created it in the 18th century. Today it is one of the largest historical vegetable gardens in Switzerland.

However, it is hardly likely that the baron would have wielded the spade himself – times have changed in this respect as well. More probably he would have paced the elegant white gravel paths while browsing one of Voltaire's works.

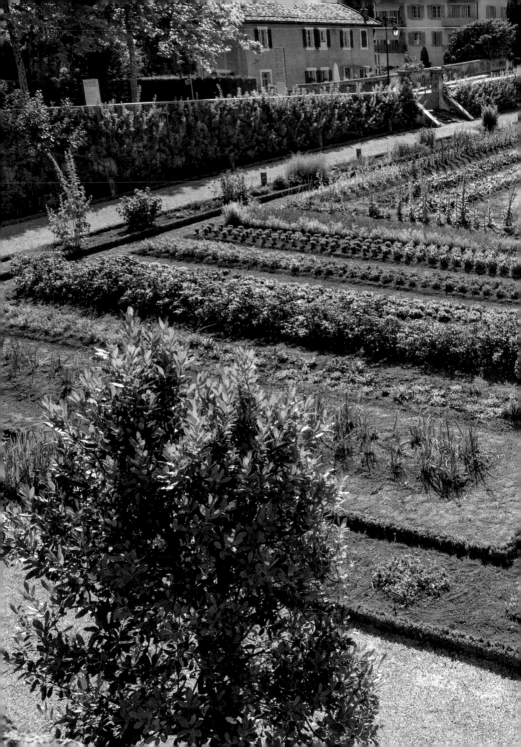

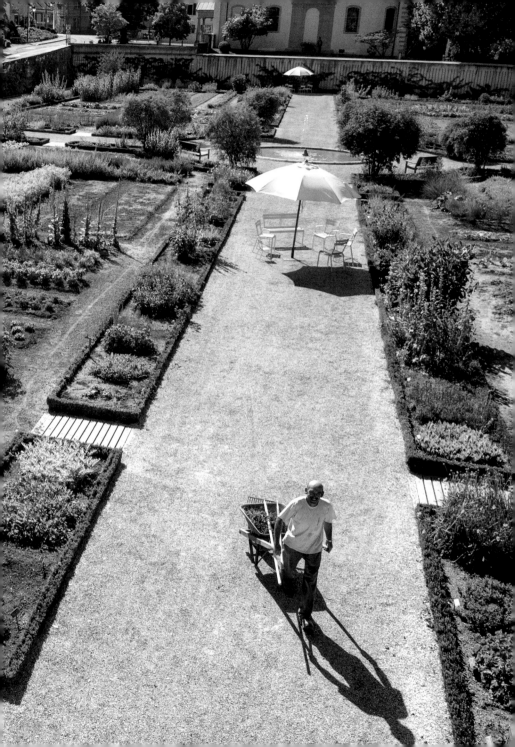

Canton of Neuchâtel
Breguet travel clock | 1796 |
fire-gilded bronze |
made in Paris by Abraham-Louis Breguet |

Napoleon was a fan of Breguet

Organisers of major sporting events, mountaineers, and even astronauts rely on Swiss timepieces today. In the past, military strategists who made history swore by Swiss clocks. For example, Napoleon Bonaparte used a pocket watch by Abraham-Louis Breguet at the Battle of Waterloo in 1815. The clients of the watchmaker from the canton of Neuchâtel included not only the French general, but also his opponents. Both the Duke of Wellington and Field Marshal Gebhard Leberecht von Blücher devised their battle strategies with Breguet watches in their pockets. Apparently Breguet was more concerned with sales than with Swiss neutrality!

Incidentally, Napoleon was a real Breguet fan and owned a total of three Breguet timepieces. The only one that has survived, however, is a travel clock kept in the Swiss National Museum.

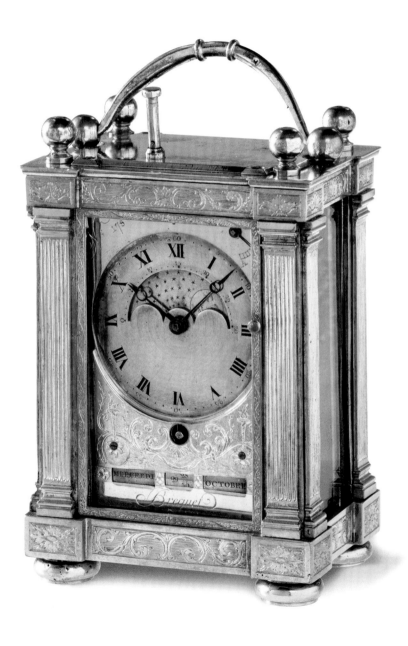

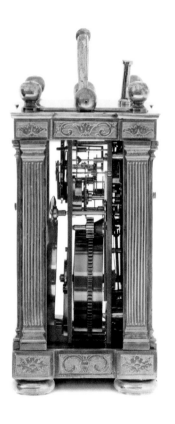
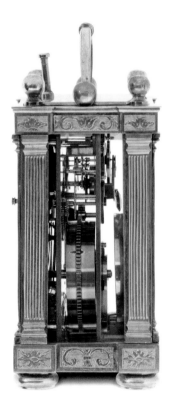

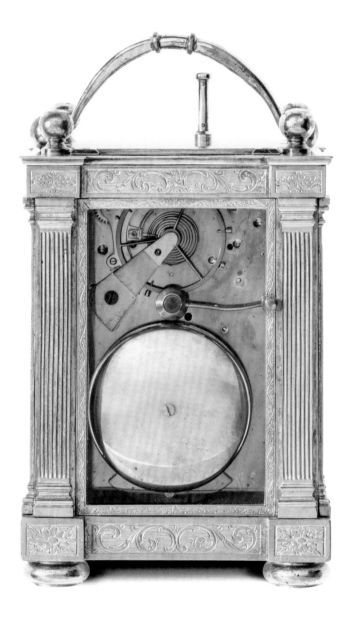

Canton of Geneva
Dufour map | 1832 |
copperplate engraving | topographical map of Switzerland |
made under the direction of Guillaume-Henri Dufour |

The birth of modern cartography

Switzerland is famous for delicious chocolate, accurate clocks, tangy cheese, and precise maps. Switzerland took the lead in map-making in the mid-19th century, when General Guillaume-Henri Dufour spearheaded a project in the canton of Geneva to create a geometrically accurate representation of Switzerland. The project was carried out between 1845 and 1864. The "Dufour Map" consists of 25 sheets and was drawn to a scale of 1:100,000. Using specially aligned strokes known as hachures, Dufour and his colleagues at the "Topographisches Bureau" were able to create representations of relief and rock formations with remarkable modelling and depth. This form of representation, which came to be called the "Swiss manner", received numerous international awards. The Swiss Federal Council responded to the success of the map in 1863 by renaming the highest peak (4634 m) in the Swiss Alps, hitherto known as the "Gornerhorn, Dufour-spitze" as a special accolade to Dufour and his cartographers.

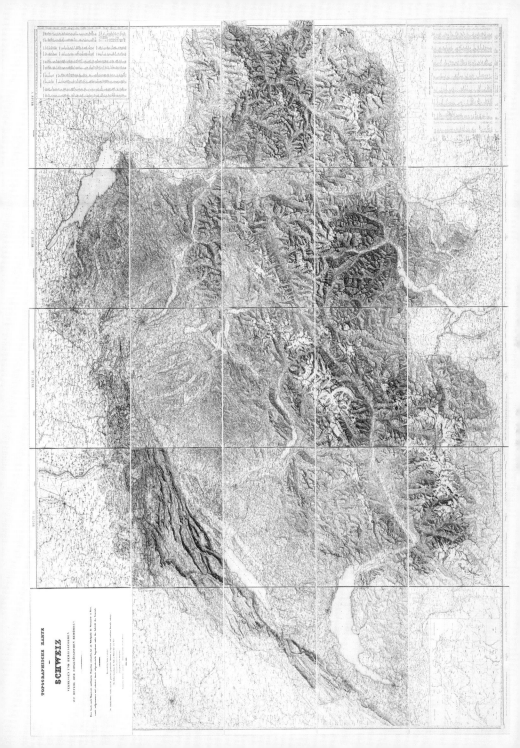

Canton of Jura
Char-de-côté, stagecoach | 1849 |
wood | iron | leather | painted |

Bumpy conditions on Switzerland's public transport

The British publisher John Murray travelled through the canton of Jura by stagecoach in 1838. He later described the trip in his "Hand-Book for Travellers" as "very rough" – hardly surprising, since the travelogue author was riding in a "char-de-côté".

On this type of coach, which was used primarily in France and western Switzerland, the carriage body was set at right angles to the undercarriage, so that the passengers sat sideways ("de côté") in relation to the direction of travel.

This was more uncomfortable, but it allowed these carriages to be built with a narrower wheelbase, and as a result the char-de-côté could be used even on those roads in the canton of Jura that were narrower than the standard track width of 1.4 metres.

Today, no travel writer would have cause to complain about the quality of Swiss public transport, which is one of the best in Europe.

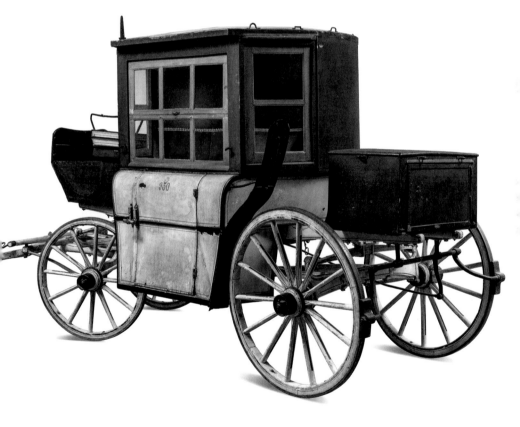

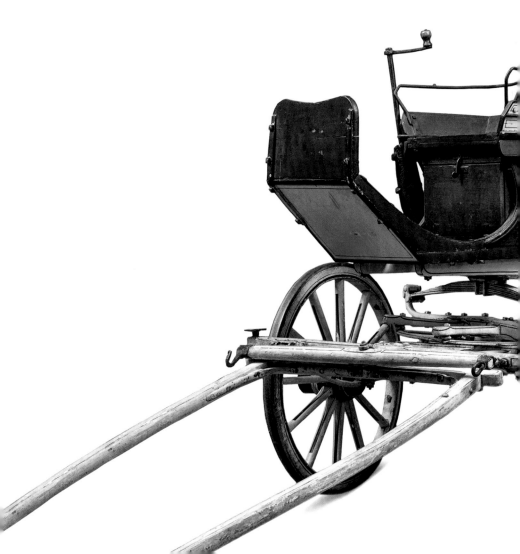

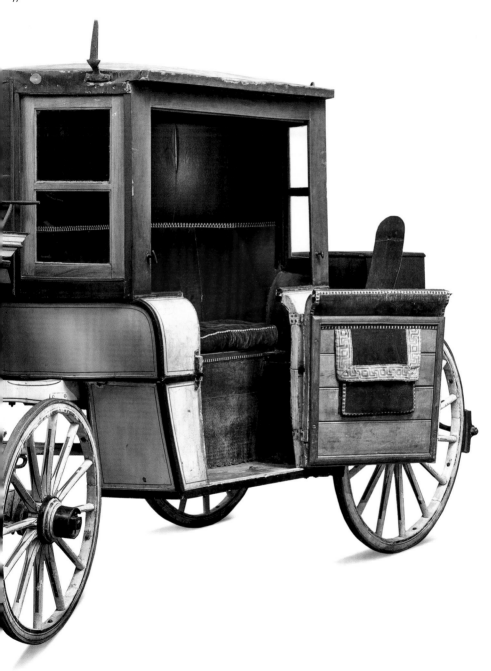

Canton of Appenzell Ausserrhoden
Whitework embroidery | 1851 |
cotton muslin | embroidered curtain |
hand-embroidered by a woman from Bühler |

Stitch by stitch

Next time you're stuck with a boring task, take comfort from the following true story. The first World Expo took place in London in 1851 and featured 13,000 works from 25 countries and 15 British colonies. One of the works was a piece of whitework embroidery from the canton of Appenzell Ausserrhoden. It was hand-embroidered, probably by just one woman, who worked on the piece for a full year, setting tens of thousands of stitches to create the design on a piece of cotton muslin measuring four square metres. The embroidery was shown to six million visitors from all over the world as a representative example of the textile crafts of eastern Switzerland.

Although the economic importance of the textile industry later declined, it still plays an integral role in the world of haute couture.

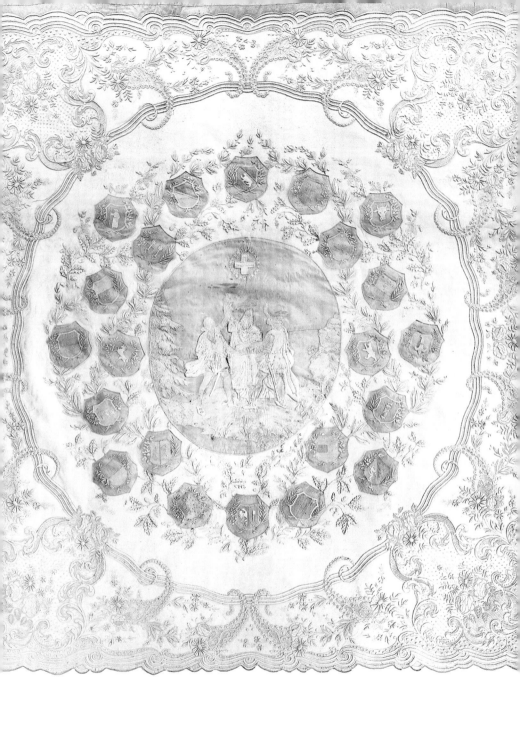

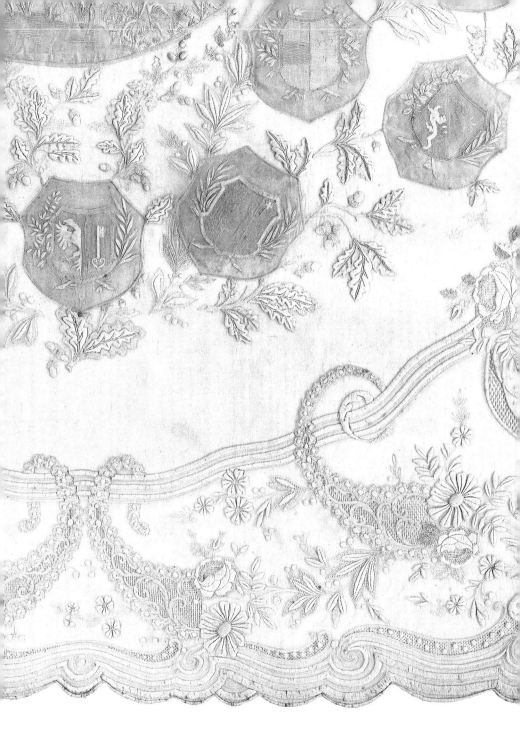

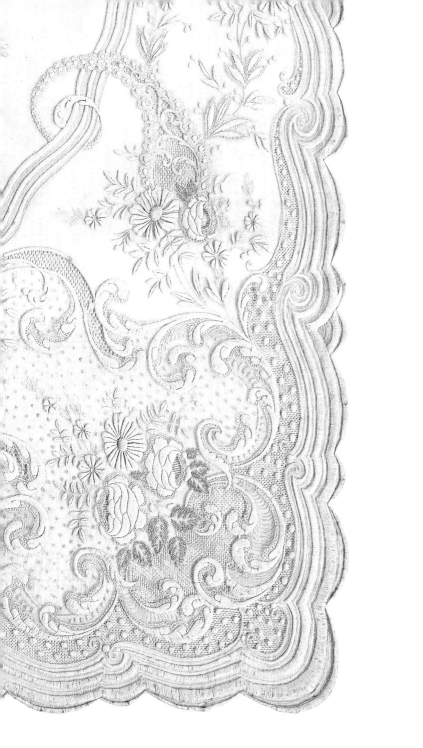

Canton of Aargau
AC Generator | 1895 |
steel |
made by Brown, Boveri & Co. in Baden |

Pioneers of electricity

In 1891, Charles Brown of Great Britain and Walter Boveri of Germany started an electrical engineering business in the canton of Aargau. During its first year, Brown, Boveri & Co. had 70 employees. Only ten years later, that number had grown to over 1500. This steep increase was partly due to the success of the alternating current generator which the company began to produce in 1895. Europe was just discovering the benefits of electricity and demand was growing by the day.

Switzerland had been an immigration country for generations and offered its new residents opportunities to realise their entrepreneurial dreams. In addition to Brown and Boveri, these immigrant entrepreneurs included the Austrian Carl Franz Bally, the founder of the shoe factory that bears his name, as well as the German pharmacist Henri Nestlé. Other famous brands like Rolex, Maggi, and Hero also owe their existence to the initiative of immigrants. The Jacobs, Hayeks, and Huxleys of this world continue to drive the Swiss economy to this day – just like a powerful generator.

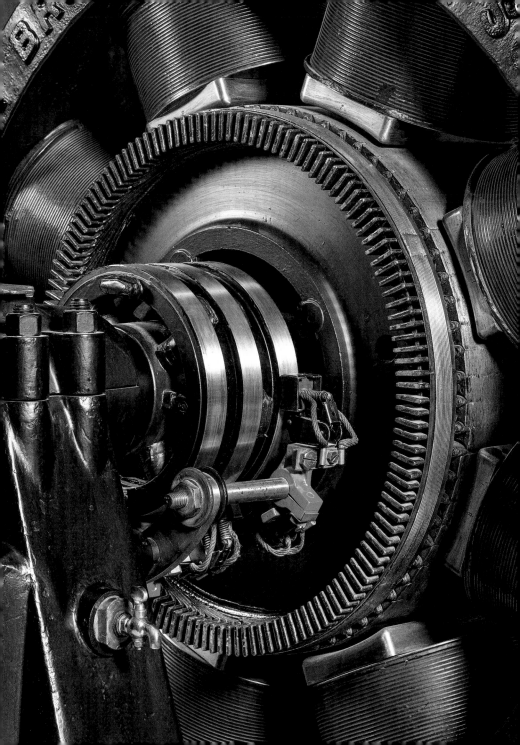

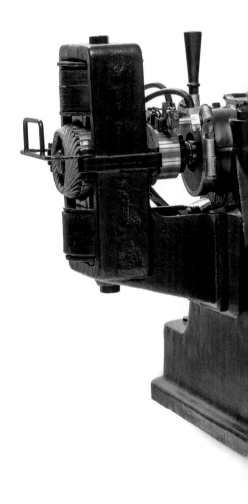

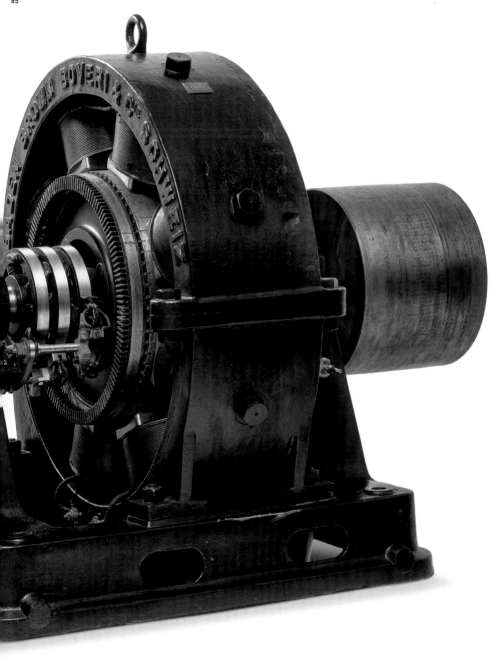

Canton of Fribourg
Cailler's Swiss Milk Chocolate | 1900 |
wood |
export box for Cailler's milk chocolate |

The dark side of chocolate

When François-Louis Cailler founded the first Swiss chocolate factory in the canton of Fribourg in 1819, it was mainly women and children who succumbed to the sweet temptation. Men preferred coffee and tobacco. This situation remained unchanged until the end of the 19th century – but the number of chocolate factories continued to increase all the same. To be able to keep growing, therefore, the new branch of industry had to persuade men to buy their product. And thanks to the army it was successful. Chocolate is highly nutritious and easy to transport and keeps well, making it a perfect choice for military rations – initially for the Swiss fusiliers and later for soldiers all over Europe. But there is a dark side to this success story, for it was World War I that helped bring about chocolate's big breakthrough. Whereas Switzerland exported 502 tons in chocolate in 1887, the figure for 1915 was 27,262 tons.

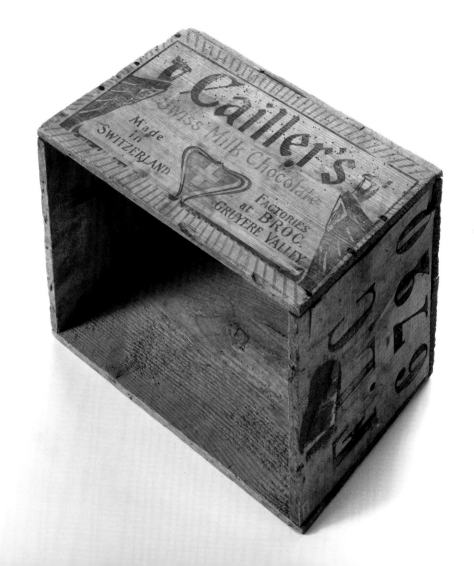

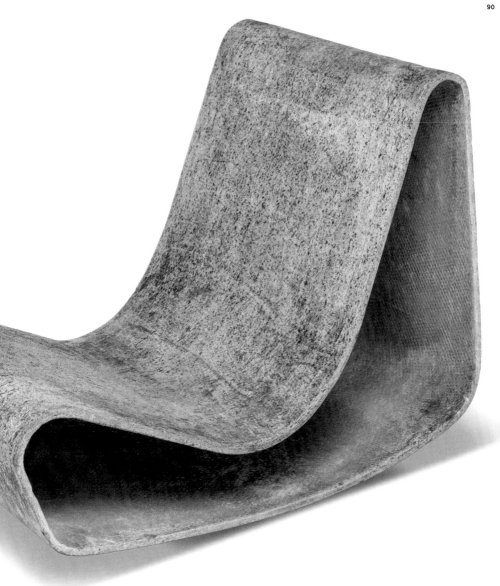

Canton of Glarus
Beach chair | 1954 |
asbestos cement | industrial manufacture |
designed by Willy Guhl | produced by Eternit AG in Niederurnen |

Classic design

Doctors agree that a seated posture is not the most ergonomic of options for the human body. In the 1940s and 1950s, the innovative Willy Guhl sought to design an anatomically sound shape for a chair. He was aided by the patrons of a swimming bath who tested his designs and described their impressions. These endeavours resulted, in 1954, in the birth of the unique beach chair whose dynamic loop shape has lost none of its appeal to this day and which has left its mark on industrial design.

Together with the company Eternit AG from the canton of Glarus, Guhl began to manufacture his chairs using asbestos cement. Soon indications emerged that asbestos was hazardous, but the carcinogenic material was not banned until the late 1980s. Fortunately, it proved possible to recreate the characteristic shape of the chair using fibre cement in 1997, when the grand master of design launched a new edition of his beach chair.

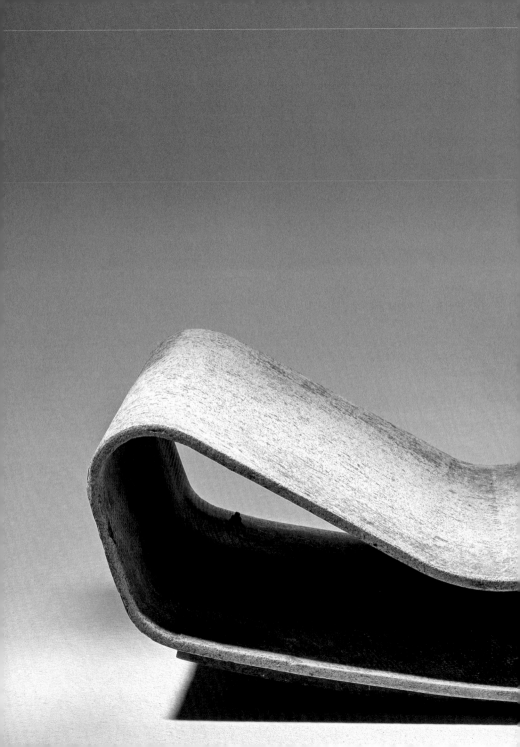

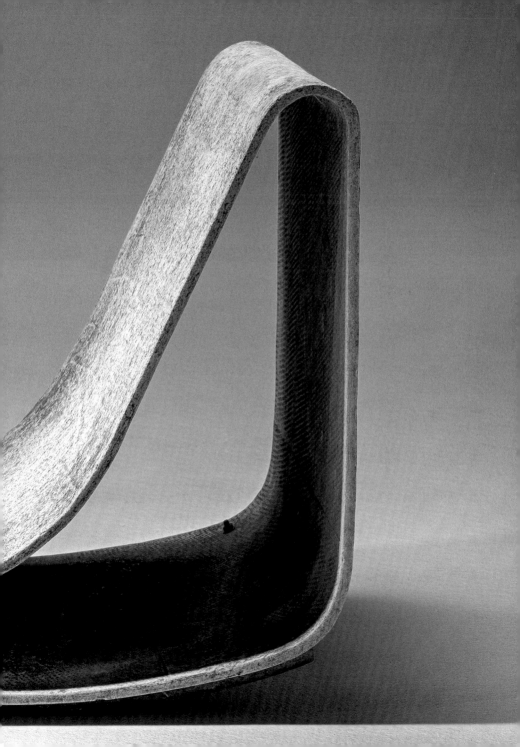

Canton of Berne
Watch Speedmaster | 1964 |
steel |
made by Omega AG in Biel |

A Swiss watch on the moon

When the American astronaut Buzz Aldrin walked on the surface of the moon on 21 July 1969, he was wearing an Omega Speedmaster wristwatch. Originally, Neil Armstrong was supposed to wear a similar watch when, prior to Aldrin, he became the first human being to set foot on the moon. However, after the moon lander's clock broke during the approach, Armstrong decided to leave his Speedmaster in the lander just to be on the safe side.

These watches, made in the Swiss city of Biel, had been chosen by the US space agency NASA because of their superior quality. Omega watches were simply better than any competing timepiece and the Speedmaster, made in the Swiss canton of Berne, was the only model that was found to be spaceworthy after stringent testing. The watches were tested under conditions of zero gravity, extreme temperatures, and high acceleration. Thus the Omega Speedmaster became the only representative of Switzerland ever to reach the moon.

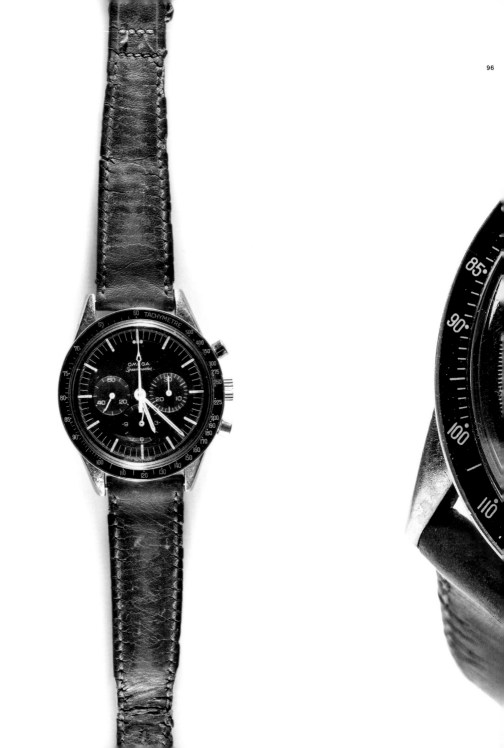

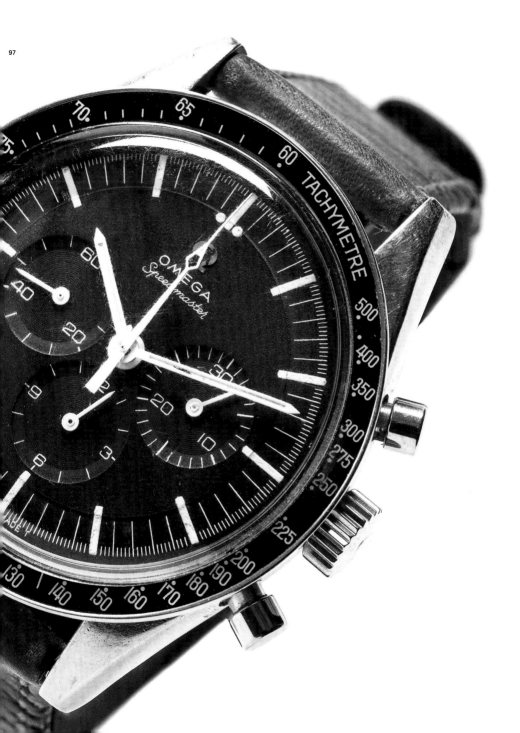

Canton of Graubünden
Snow cannon | 1978 |
aluminium pipe with two jets |
first used in Savognin |

Out of the blue sky

"Switzerland's peaks are virtually devoid of snow, but in Savognin the snow falls from clear skies," wrote the newspaper *Bündner Tagblatt* on 9 December 1978. On that day, ten snow cannons provided enough snow for a three-kilometre piste on a green slope in the canton of Graubünden. When the first major artificial snow-blowing system in Europe went into operation, this marked the dawn of a new era in winter tourism. The snow cannons that caused a stir at the time are taken for granted today in every skiing resort of any size.

Snow cannons were invented in Canada in 1940, when a team of researchers was studying the icing up of jet engines in a wind tunnel. While spraying water into a running turbine at sub-zero temperatures, the scientists had to contend with an undesirable side-effect: snow, which kept accumulating at the rear of the wind tunnel. What was an annoyance to those early researchers later became one of the biggest innovations in winter sports.

Canton of Obwalden
DC motor RE 25 | 2004 |
metal | electrical elements |
made by Maxon Motors in Sachseln |

From Oberwalden straight to Mars

We generally associate high-tech with vibrant metropolitan cities. Would anyone really expect to find a manufacturer of state-of-the-art space technology on the idyllic shores of Lake Sarnen? Probably not, but they would be wrong. The village of Sachseln is the home of Maxon Motors, which rose to worldwide fame in 2004, when it supplied 39 electric motors for the Mars Exploration Rover "Opportunity". Maxon's motors are not only technically advanced, but durable as well. Originally, NASA's Mars expedition was supposed to spend only 90 days on the surface of the red planet.

But "Opportunity" celebrated its tenth anniversary in 2014. Nobody would have thought that the motors could withstand the extreme climatic conditions of Mars for more than three months! Another Mars mission is scheduled to launch in 2018. This time it is the European Space Agency ESA that will send a rover to explore the red planet. But once again the rover will be powered by motors from the canton of Obwalden.

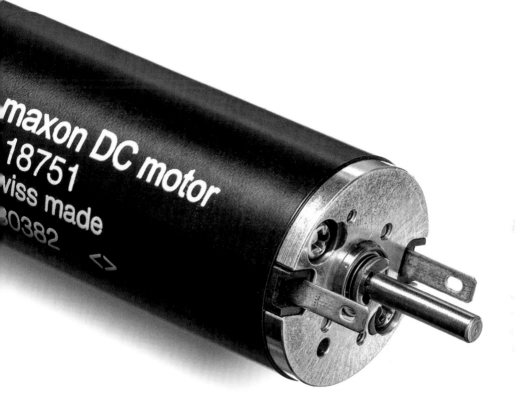

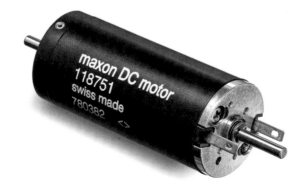

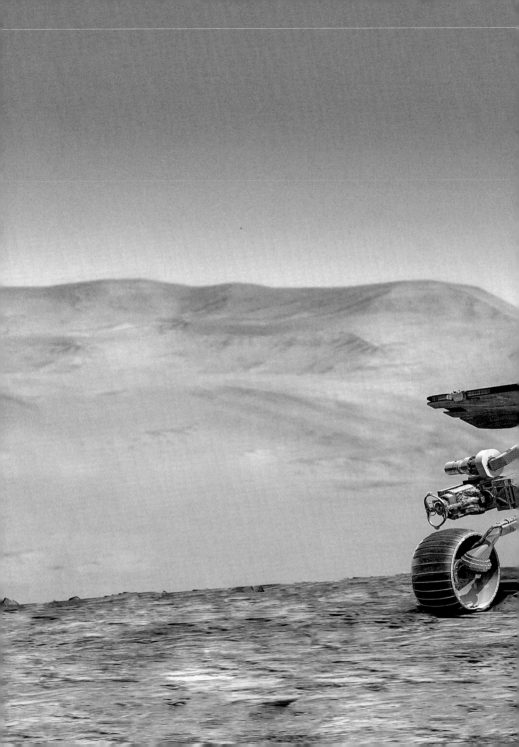

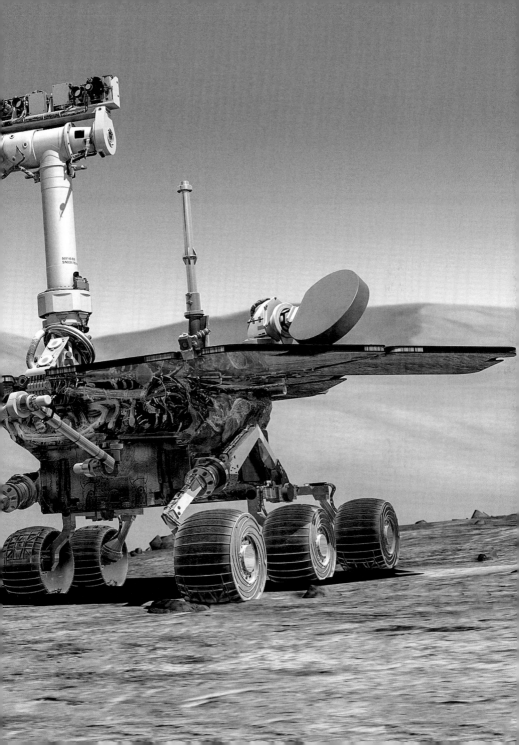

Canton of Basel-Stadt
LSD (lysergic acid diethylamide) | 2007 |
made by Laboratorium Dr. G. Bichsel |
for Dr. P. Gasser |

Albert Hofmann's high-speed bicycle trip

In 1938, Albert Hofmann, a researcher at the Sandoz corporation based in the canton of Basel-Stadt, began a series of studies to develop a stimulant from a crop fungus. The 25th substance in the series was lysergic acid diethylamide or LSD-25, which he tested on himself in 1943. Feeling dizzy in the laboratory, he decided to go home – on his bicycle. Although he thought he was going slowly, he was actually cycling at breakneck speed. Everything he saw was distorted, as though in a curved mirror. He later described his neighbour as looking like a "witch with a colourful visage" – thus documenting the first LSD trip in history.

Sandoz continued to produce the substance for medical use until 1966. It became a hippie drug in the 1970s and was banned worldwide, even for medical purposes. Recently, however, a Swiss psychiatrist was able to carry out another patient study using LSD – with positive results.

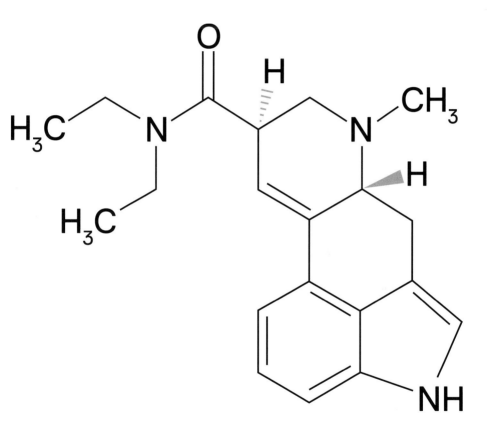

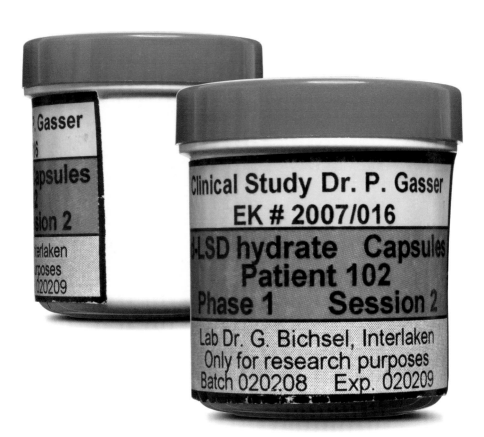

Clinical Study Dr. P. Gasser
EK # 2007/016
d-LSD hydrate Capsules
Patient 102
Phase 1 Session 2
Lab Dr. G. Bichsel, Interlaken
Only for research purposes
Batch 020208 Exp. 020209

List of objects

This book marks
the opening of the new
National Museum Zurich
on 1 August 2016.

Publisher
The Swiss National Museum

Texts
Andrej Abplanalp

Heidi Amrein, Adrian Baschung,
Helen Bieri Thomson, Jürg Burlet,
Andrea Franzen, Felix Graf,
Erika Hebeisen, Serge Hediger,
Susanne Huber, Christine Keller,
Hanspeter Lanz, Pascale Meyer,
Mylène Ruoss, Bernard Schüle,
Christina Sonderegger, Andreas
Spillmann, Luca Tori, Samuel van
Willigen

Coordination
Eliane Burckhardt Pauli

Design
Urs Stuber and Susanna Entress

**Translation, copyediting,
and proofreading**
Tradukas GbR, Düsseldorf

**Lithography, printing,
and binding**
DZA Druckerei
zu Altenburg GmbH,
Thüringen

Cover image:
Cailler's Swiss Milk Chocolate
(Page 86)

Copyright for the texts,
© by the authors
Copyright for the photographs
of the objects, © The Swiss National
Museum / Donat Stuppan
Page 62: © Benoit Aymon, RTS
Page 71: © swisstopo
Page 95: Private photograph
Page 104/105: NASA/JPL-Caltech

Copyright © 2016 The Swiss National
Museum and Verlag
Scheidegger & Spiess AG, Zurich

ISBN 978-3-85881-780-8

German edition
ISBN 978-3-85881-511-8

French edition
ISBN 978-3-85881-781-5

Italian edition
ISBN 978-3-85881-782-2

Verlag Scheidegger & Spiess AG
Niederdorfstrasse 54
CH – 8001 Zürich

www.scheidegger-spiess.ch